DECORATE

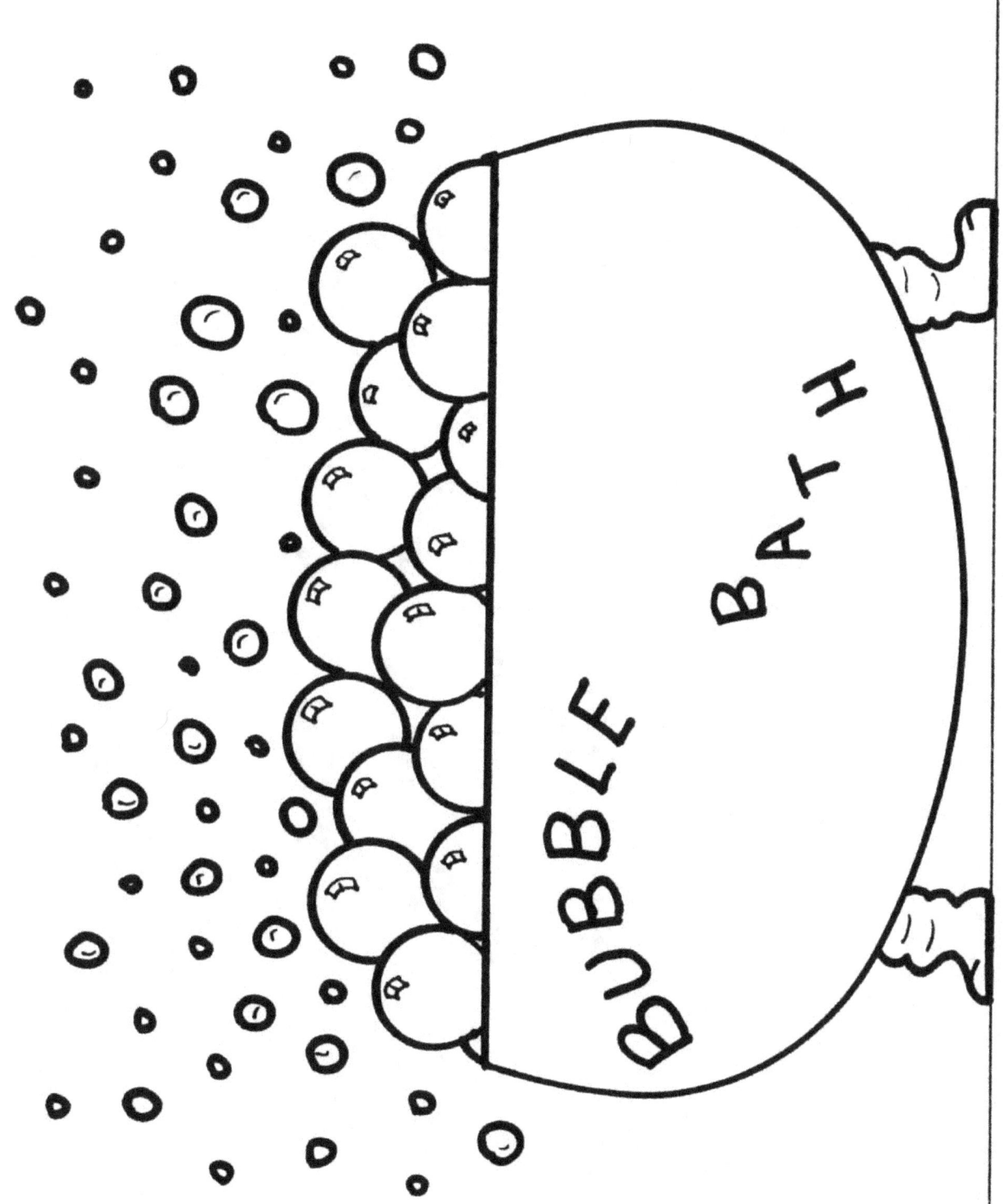

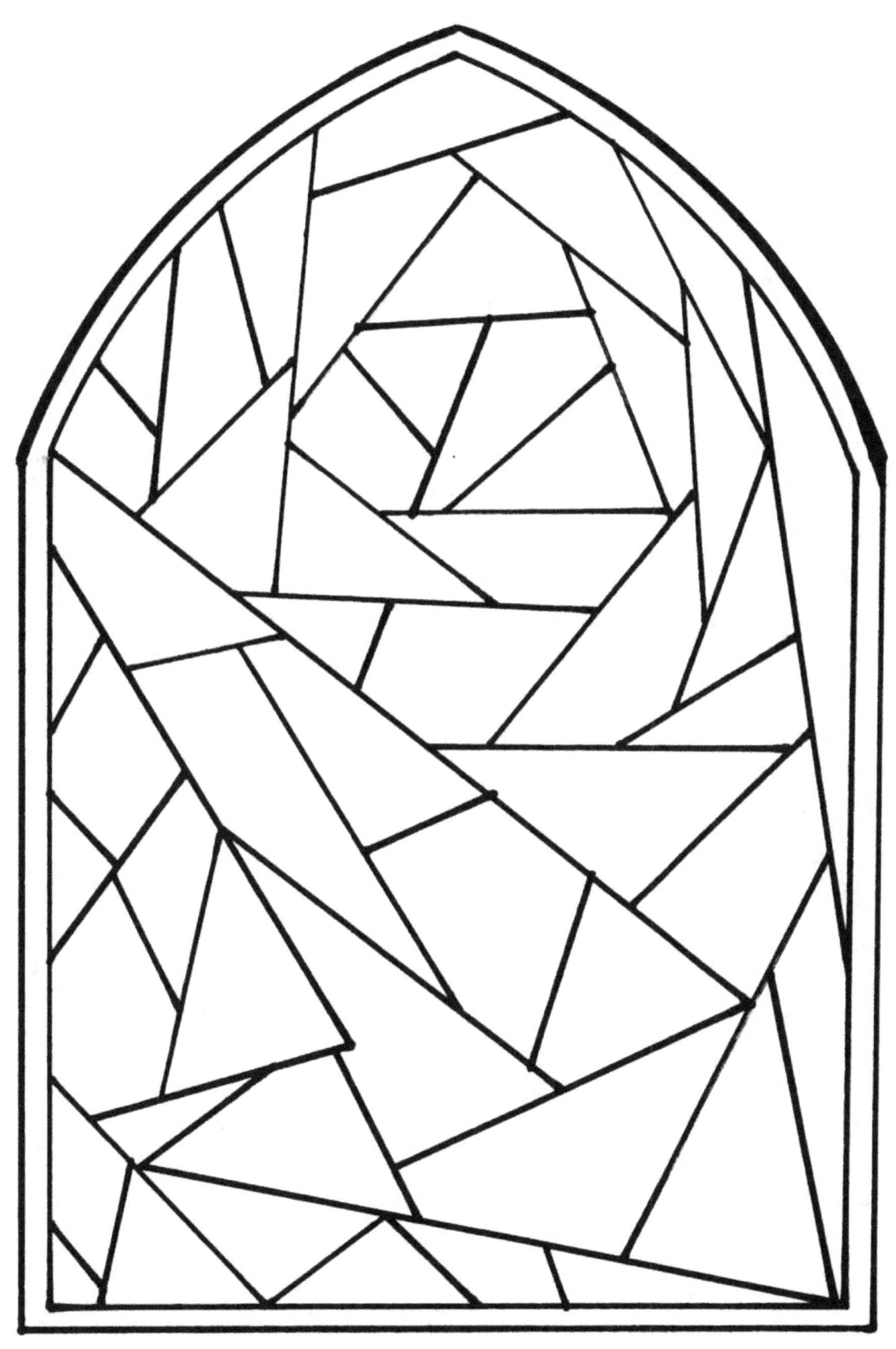

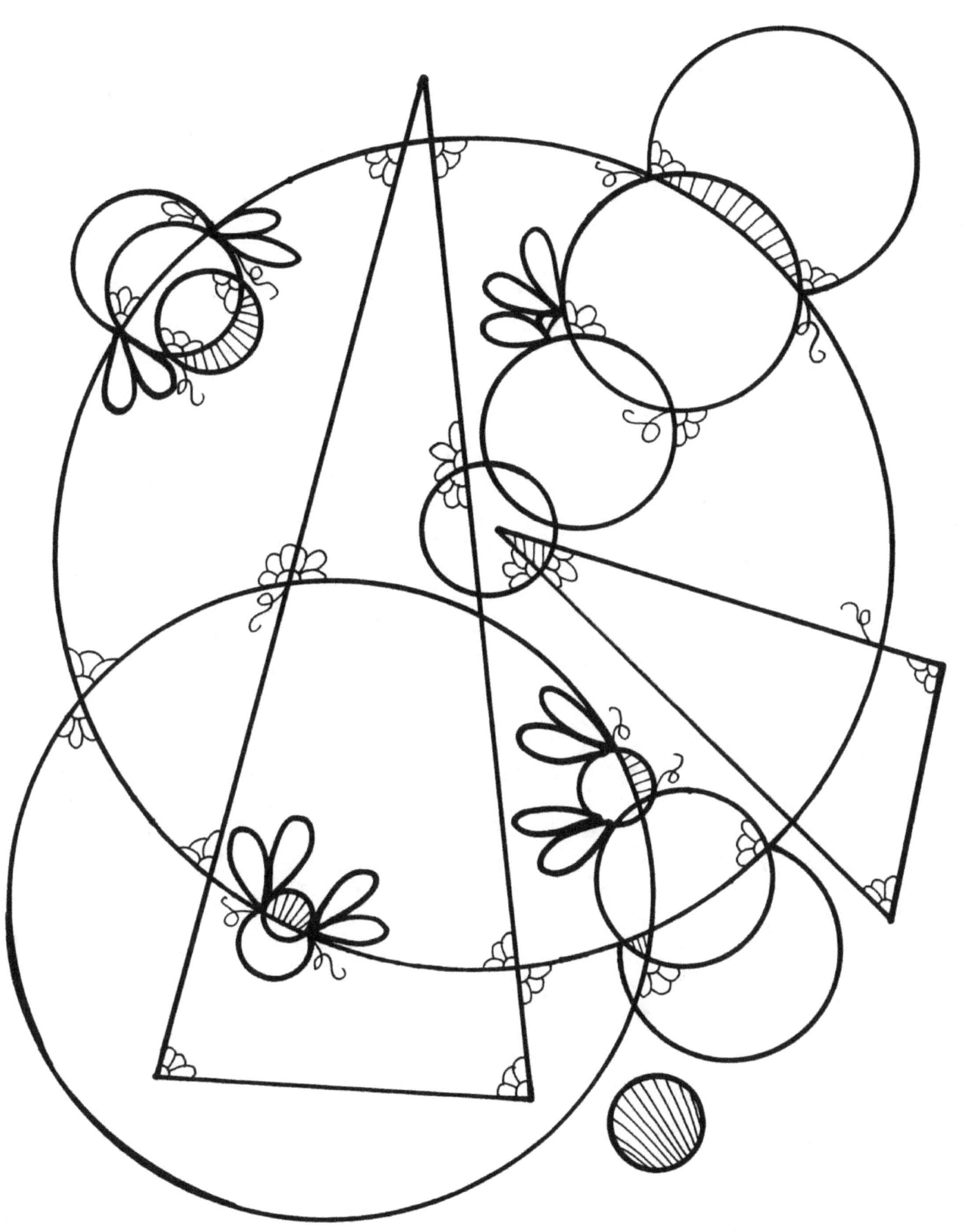

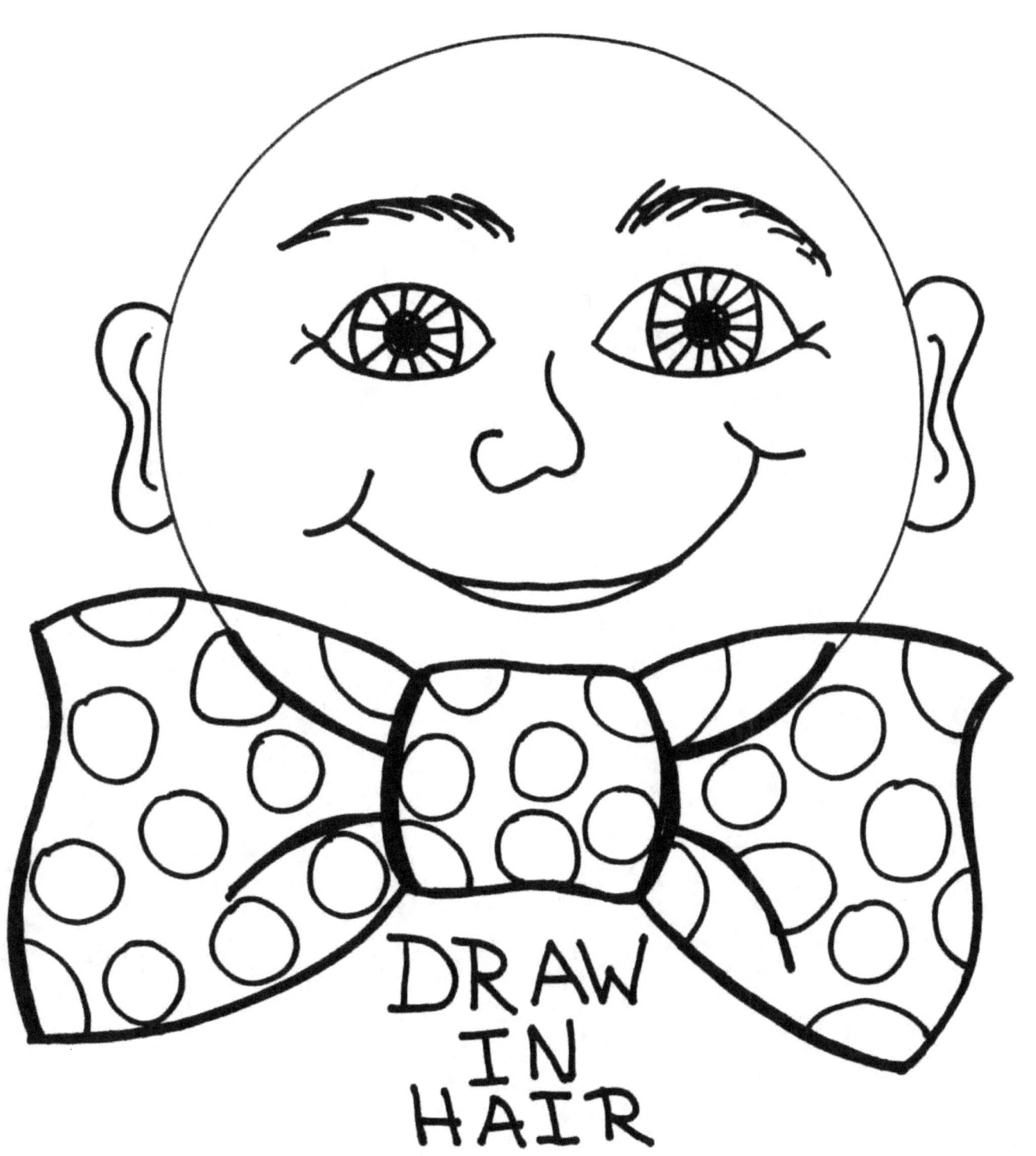

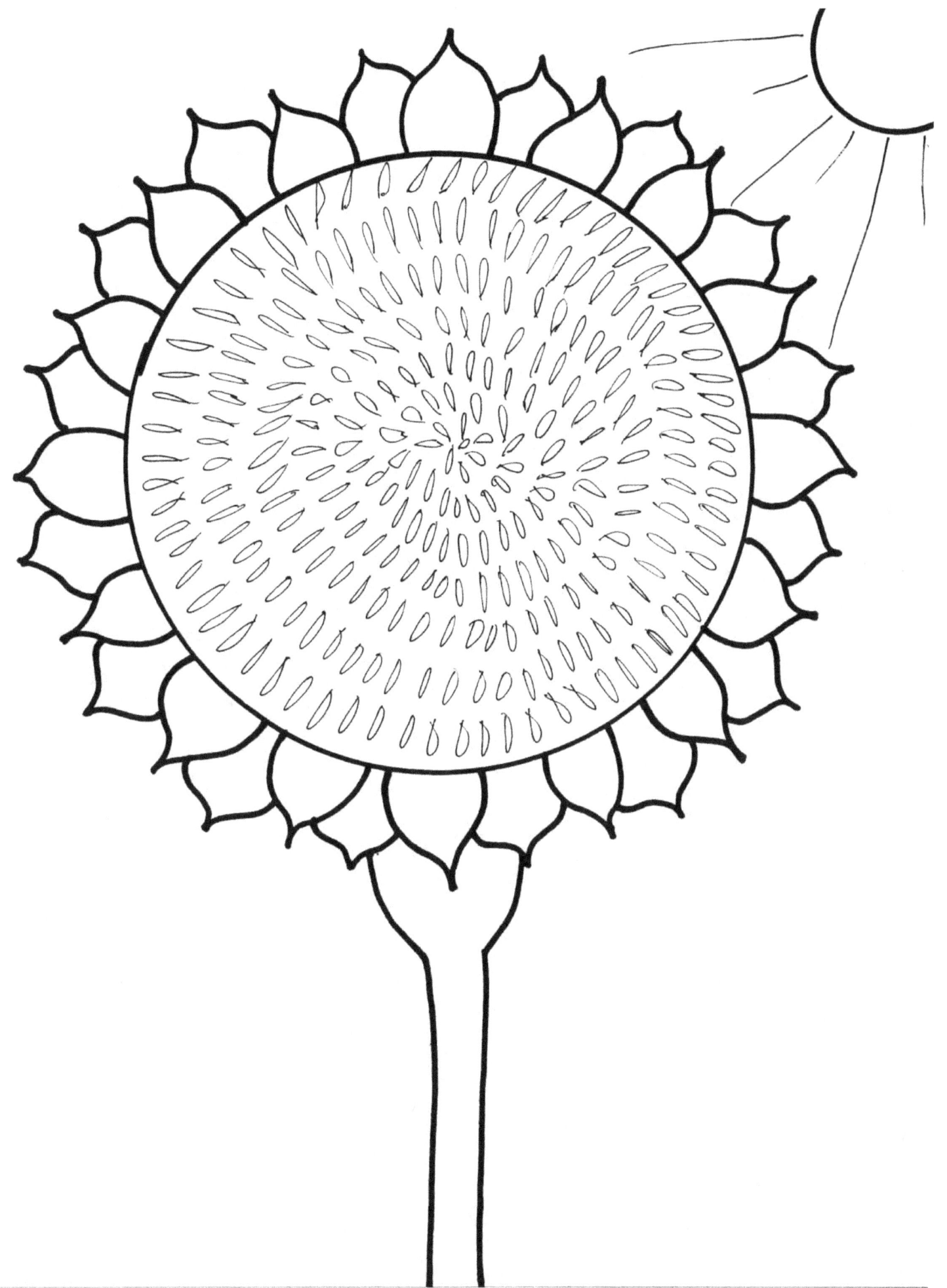

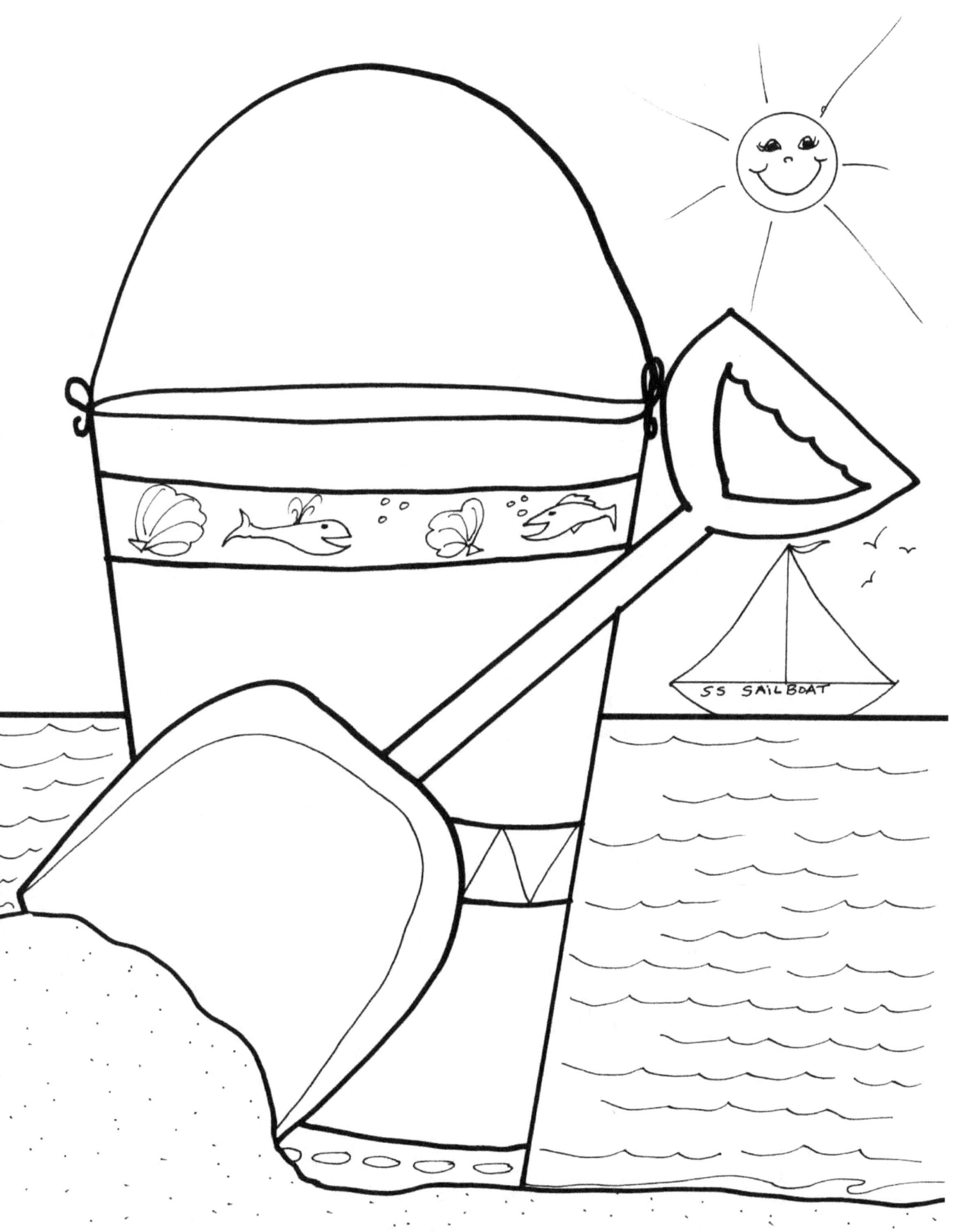

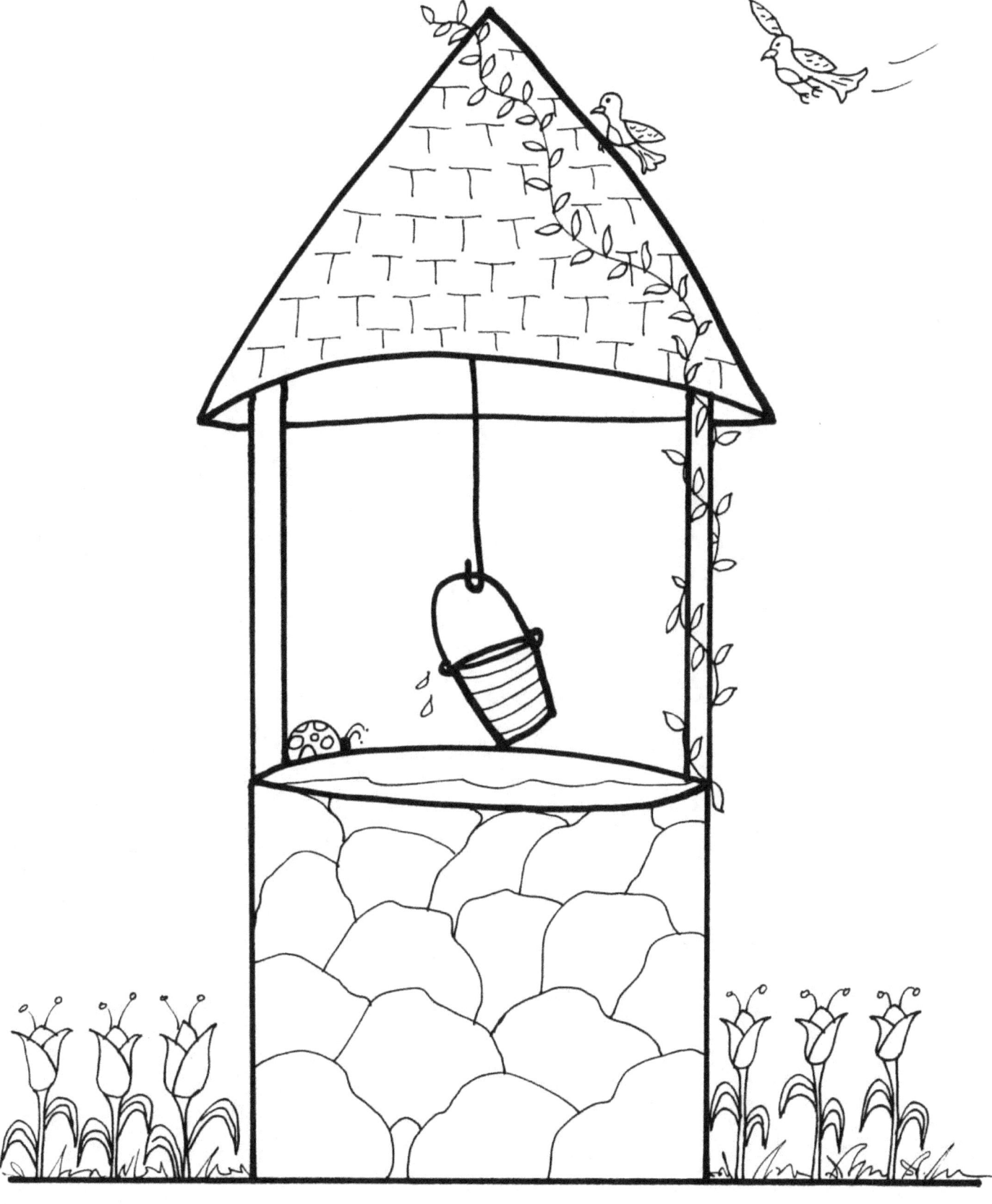

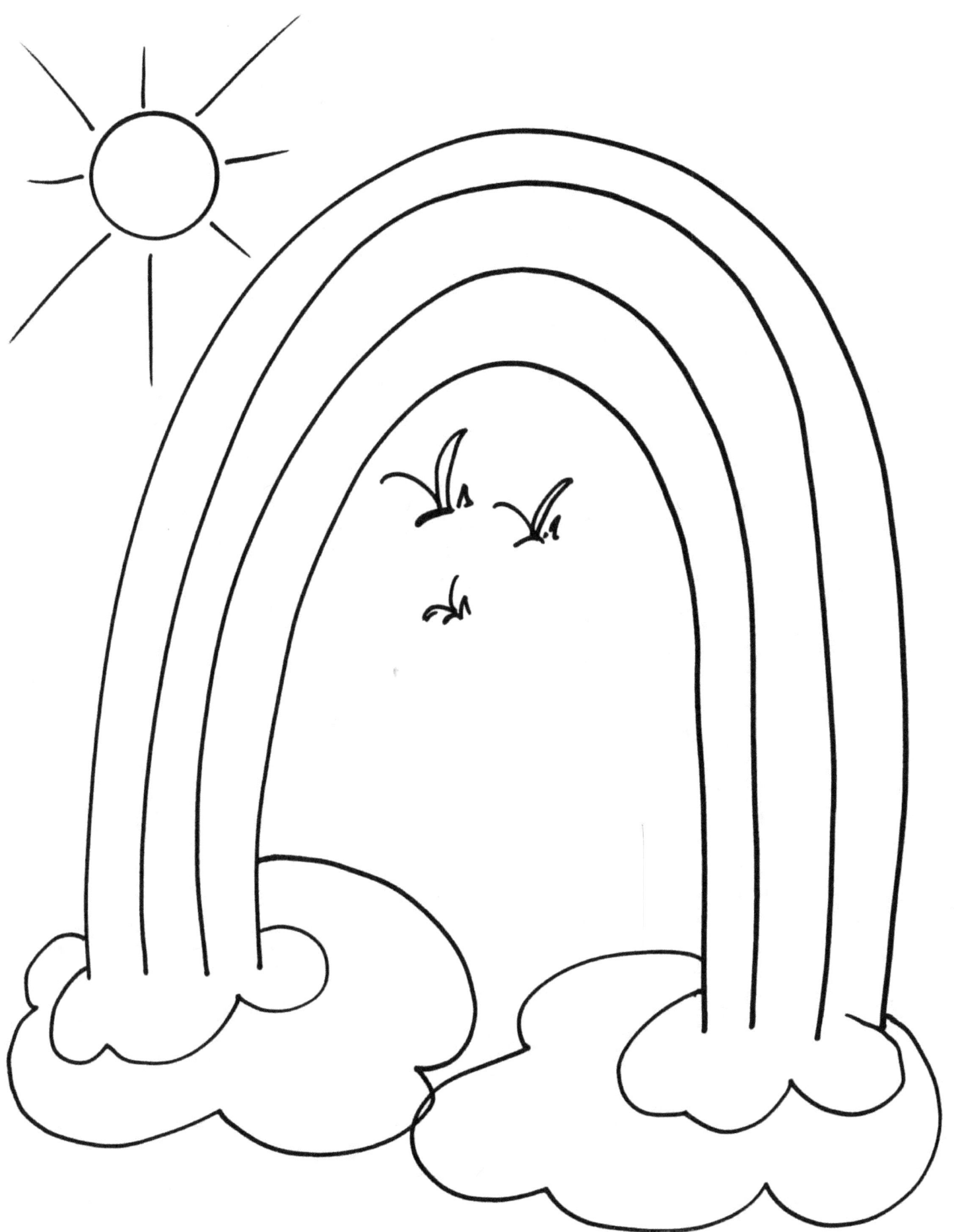

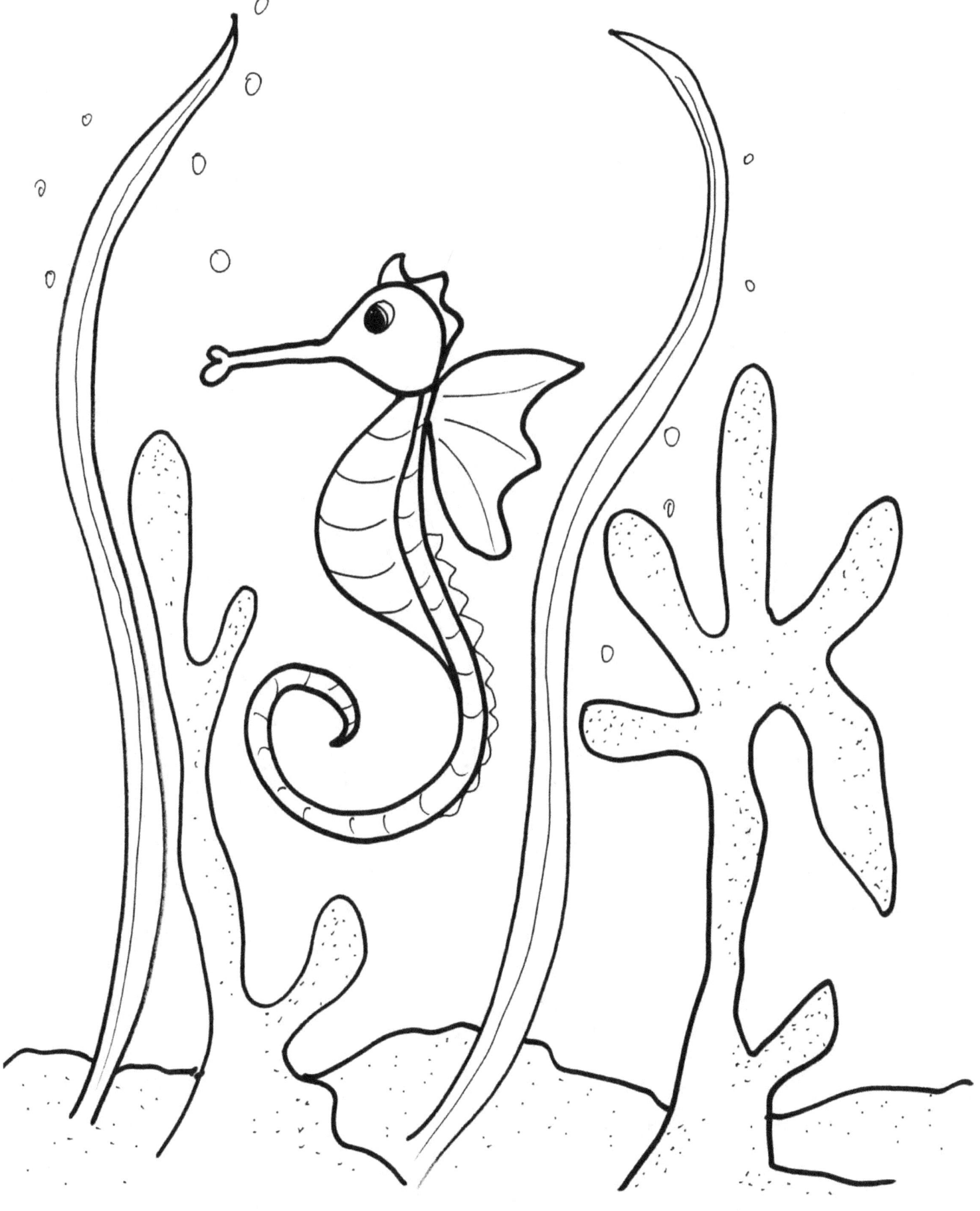

FAMILY COLORING BOOK

CREATOR/ILLUSTRATOR: ROBERTA M. O'CONNELL

PUBLISHED BY: PRINCESS PUBLISHERS ~ UXBRIDGE, MA 2017

COPYRIGHT: ROBERTA M. O'CONNELL

NO PART OF THIS BOOK MAY BE COPIED IN ANY FORMAT WITHOUT EXPRESS PERMISSION FROM PRINCESS PUBLISHERS. **Robertaoconnell7@gmail.com**

I WISH TO THANK GOD FOR THE GIFT OF ART, MY HUSBAND FOR HIS GREAT IDEAS AND SUPPORT AND MOM, WHO BOUGHT ME MY FIRST BOX OF OIL PASTELS WHEN I WAS YOUNG. MANY THANKS TO GRAMPA H. WHO TAUGHT ME HOW TO DRAW SO MUCH AND TEACHERS WHO ENCOURAGED ME.

PLEASE LOOK FOR ALL 16 TITLES BY ROBERTA M. O'CONNELL AVAILABLE INTERNATIONALLY. THESE INCLUDE CHILDREN'S BOOKS, NOVELS, DEVOTIONALS, DIABETES HELP, POETRY AND MORE.

www.ingramcontent.com/pod-product-compliance
Lightning Source LLC
Chambersburg PA
CBHW080010210526

45170CB00015B/1960